SUGAR SKULL
COLOR BY NUMBER
FOR ADULTS

COPYRIGHT 2019
NOX SMITH

Copyright 2018-2019 Nox Smith. All Right Reserved.

Nox Smith brand coloring books are created by a team of independent artists.

No part of this book may be reproduced or transmitted in any form or by any means, electronic or mechanical, including photocopying, recording or by any information storage and retrieval system, without written permission form the publisher.

The information provided with this book is for general information purpose only. While we try to keep the information up-to-date and correct there are no representation or warranties, express or implied, about the completeness, accuracy, reliability or availability with respect to the information, product, service, or related graphics contained in this book for any purpose.

COLOR PALETTE

- ⓪ White
- ① Yellow
- ② Light Orange
- ③ Dark Orange
- ④ Cream
- ⑤ Red
- ⑥ Dark Red
- ⑦ Pink
- ⑧ Violet
- ⑨ Dark Pink
- ⑩ Dark Purple
- ⑪ Light Blue
- ⑫ Sky Blue
- ⑬ Medium Blue
- ⑭ Dark Blue
- ⑮ Yellow Green
- ⑯ Medium Green
- ⑰ Bright Green
- ⑱ Dark Green
- ⑲ Tan
- ⑳ Light Brown
- ㉑ Dark Brown
- ㉒ Light Gray
- ㉓ Dark Gray
- ㉔ Black

The world is my canvas and I create my reality.

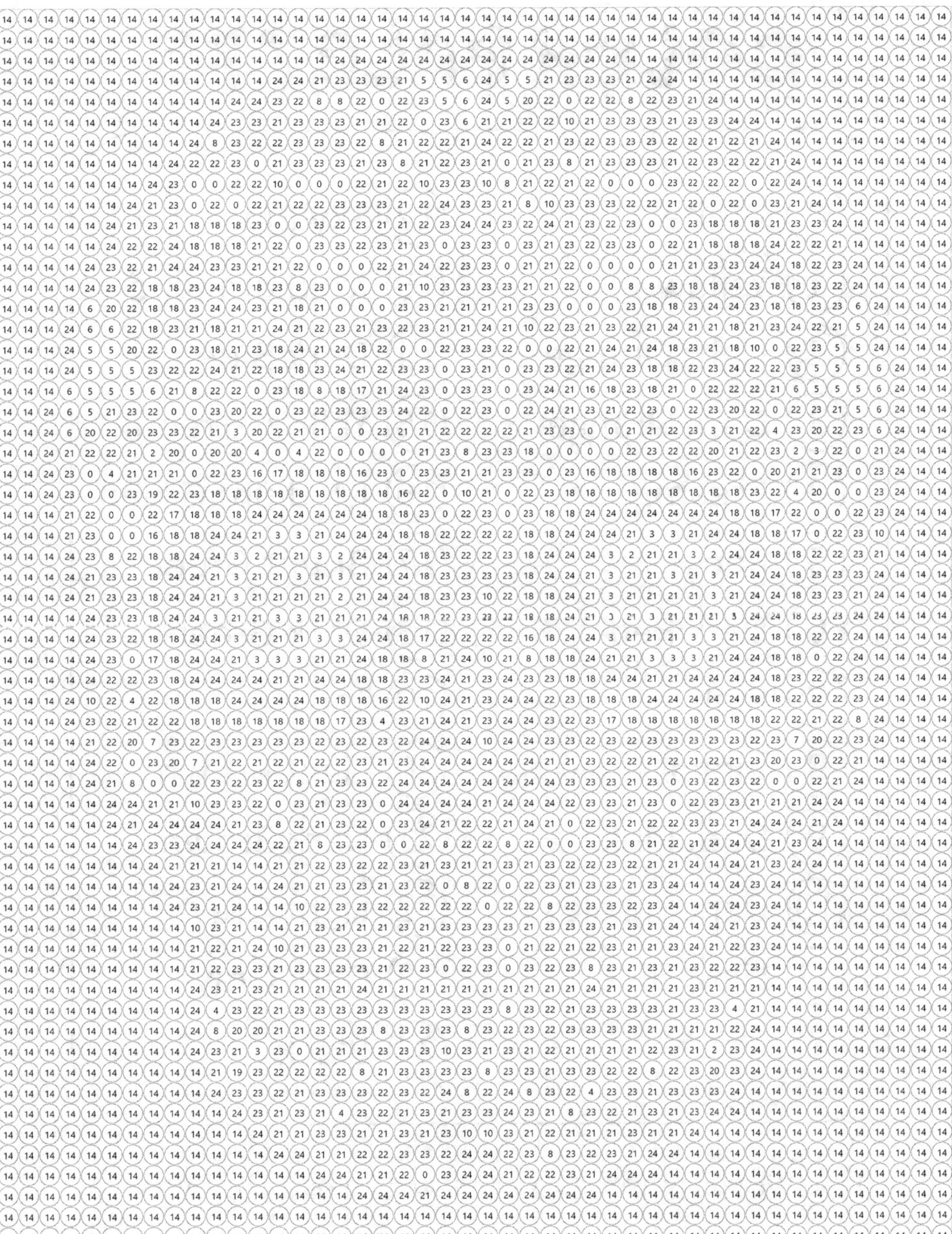

COLOR PALETTE

- ⓪ White
- ① Yellow
- ② Light Orange
- ③ Dark Orange
- ④ Cream
- ⑤ Red
- ⑥ Dark Red
- ⑦ Pink
- ⑧ Violet
- ⑨ Dark Pink
- ⑩ Dark Purple
- ⑪ Light Blue
- ⑫ Sky Blue
- ⑬ Medium Blue
- ⑭ Dark Blue
- ⑮ Yellow Green
- ⑯ Medium Green
- ⑰ Bright Green
- ⑱ Dark Green
- ⑲ Tan
- ⑳ Light Brown
- ㉑ Dark Brown
- ㉒ Light Gray
- ㉓ Dark Gray
- ㉔ Black

The world is my canvas and I create my reality.

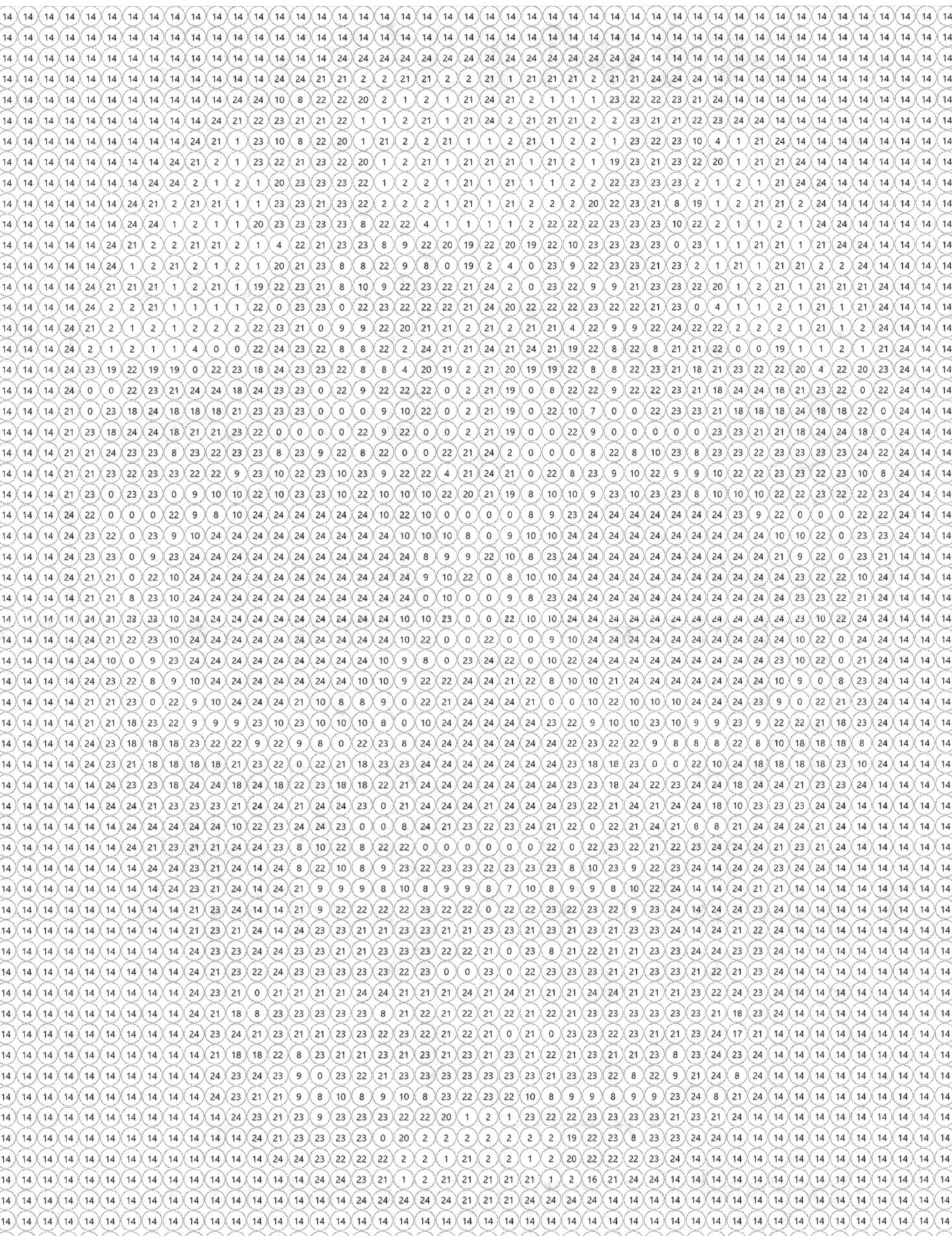

COLOR PALETTE

- ⓪ White
- ① Yellow
- ② Light Orange
- ③ Dark Orange
- ④ Cream
- ⑤ Red
- ⑥ Dark Red
- ⑦ Pink
- ⑧ Violet
- ⑨ Dark Pink
- ⑩ Dark Purple
- ⑪ Light Blue
- ⑫ Sky Blue
- ⑬ Medium Blue
- ⑭ Dark Blue
- ⑮ Yellow Green
- ⑯ Medium Green
- ⑰ Bright Green
- ⑱ Dark Green
- ⑲ Tan
- ⑳ Light Brown
- ㉑ Dark Brown
- ㉒ Light Gray
- ㉓ Dark Gray
- ㉔ Black

The world is my canvas and I create my reality.

COLOR PALETTE

- ⓪ White
- ① Yellow
- ② Light Orange
- ③ Dark Orange
- ④ Cream
- ⑤ Red
- ⑥ Dark Red
- ⑦ Pink
- ⑧ Violet
- ⑨ Dark Pink
- ⑩ Dark Purple
- ⑪ Light Blue
- ⑫ Sky Blue
- ⑬ Medium Blue
- ⑭ Dark Blue
- ⑮ Yellow Green
- ⑯ Medium Green
- ⑰ Bright Green
- ⑱ Dark Green
- ⑲ Tan
- ⑳ Light Brown
- ㉑ Dark Brown
- ㉒ Light Gray
- ㉓ Dark Gray
- ㉔ Black

The world is my canvas and I create my reality.

COLOR PALETTE

- ⓪ White
- ① Yellow
- ② Light Orange
- ③ Dark Orange
- ④ Cream
- ⑤ Red
- ⑥ Dark Red
- ⑦ Pink
- ⑧ Violet
- ⑨ Dark Pink
- ⑩ Dark Purple
- ⑪ Light Blue
- ⑫ Sky Blue
- ⑬ Medium Blue
- ⑭ Dark Blue
- ⑮ Yellow Green
- ⑯ Medium Green
- ⑰ Bright Green
- ⑱ Dark Green
- ⑲ Tan
- ⑳ Light Brown
- ㉑ Dark Brown
- ㉒ Light Gray
- ㉓ Dark Gray
- ㉔ Black

The world is my canvas and I create my reality.

COLOR PALETTE

- ⓪ White
- ① Yellow
- ② Light Orange
- ③ Dark Orange
- ④ Cream
- ⑤ Red
- ⑥ Dark Red
- ⑦ Pink
- ⑧ Violet
- ⑨ Dark Pink
- ⑩ Dark Purple
- ⑪ Light Blue
- ⑫ Sky Blue
- ⑬ Medium Blue
- ⑭ Dark Blue
- ⑮ Yellow Green
- ⑯ Medium Green
- ⑰ Bright Green
- ⑱ Dark Green
- ⑲ Tan
- ⑳ Light Brown
- ㉑ Dark Brown
- ㉒ Light Gray
- ㉓ Dark Gray
- ㉔ Black

The world is my canvas and I create my reality.

COLOR PALETTE

- ⓪ White
- ① Yellow
- ② Light Orange
- ③ Dark Orange
- ④ Cream
- ⑤ Red
- ⑥ Dark Red
- ⑦ Pink
- ⑧ Violet
- ⑨ Dark Pink
- ⑩ Dark Purple
- ⑪ Light Blue
- ⑫ Sky Blue
- ⑬ Medium Blue
- ⑭ Dark Blue
- ⑮ Yellow Green
- ⑯ Medium Green
- ⑰ Bright Green
- ⑱ Dark Green
- ⑲ Tan
- ⑳ Light Brown
- ㉑ Dark Brown
- ㉒ Light Gray
- ㉓ Dark Gray
- ㉔ Black

The world is my canvas and I create my reality.

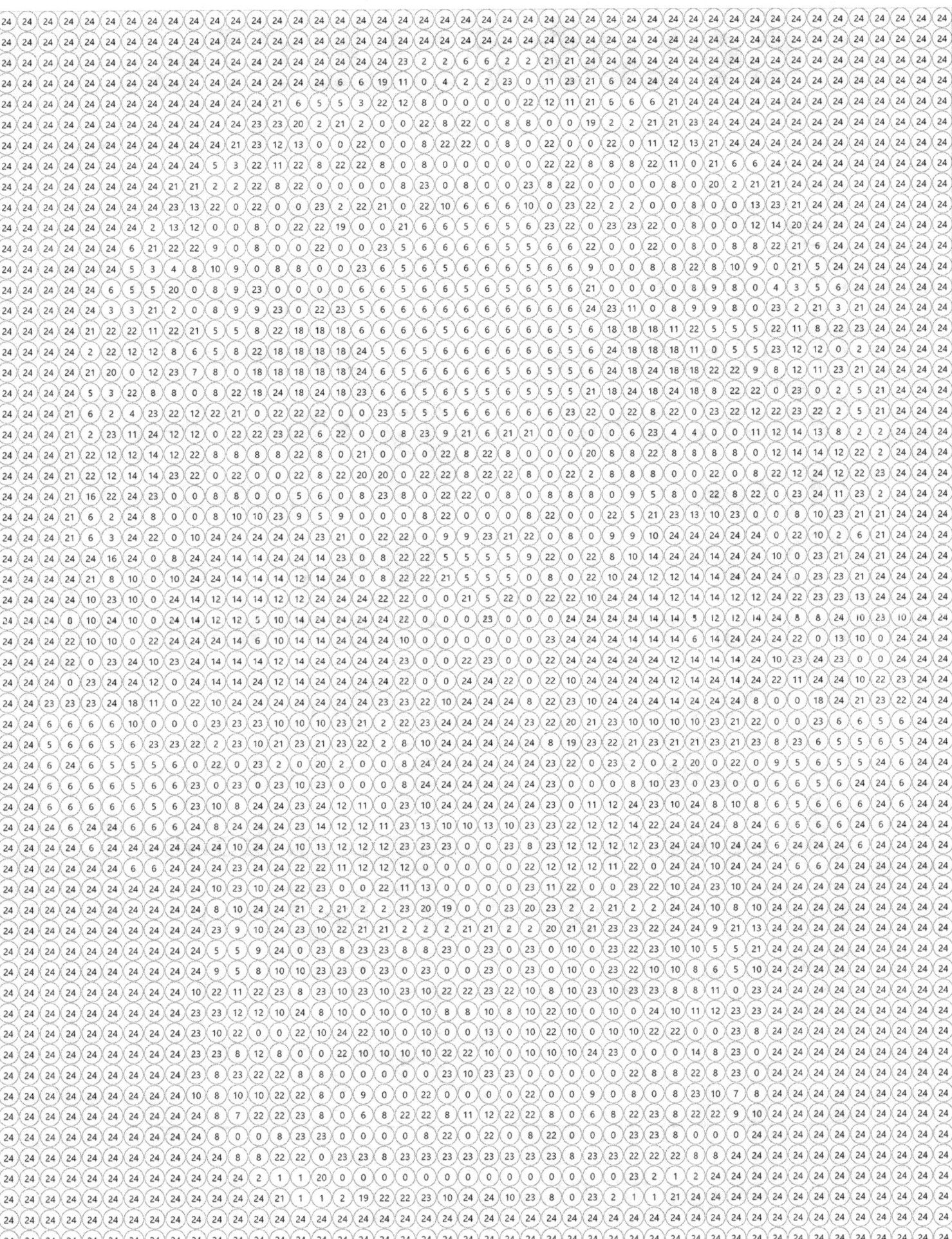

COLOR PALETTE

- ⓪ White
- ① Yellow
- ② Light Orange
- ③ Dark Orange
- ④ Cream
- ⑤ Red
- ⑥ Dark Red
- ⑦ Pink
- ⑧ Violet
- ⑨ Dark Pink
- ⑩ Dark Purple
- ⑪ Light Blue
- ⑫ Sky Blue
- ⑬ Medium Blue
- ⑭ Dark Blue
- ⑮ Yellow Green
- ⑯ Medium Green
- ⑰ Bright Green
- ⑱ Dark Green
- ⑲ Tan
- ⑳ Light Brown
- ㉑ Dark Brown
- ㉒ Light Gray
- ㉓ Dark Gray
- ㉔ Black

The world is my canvas and I create my reality.

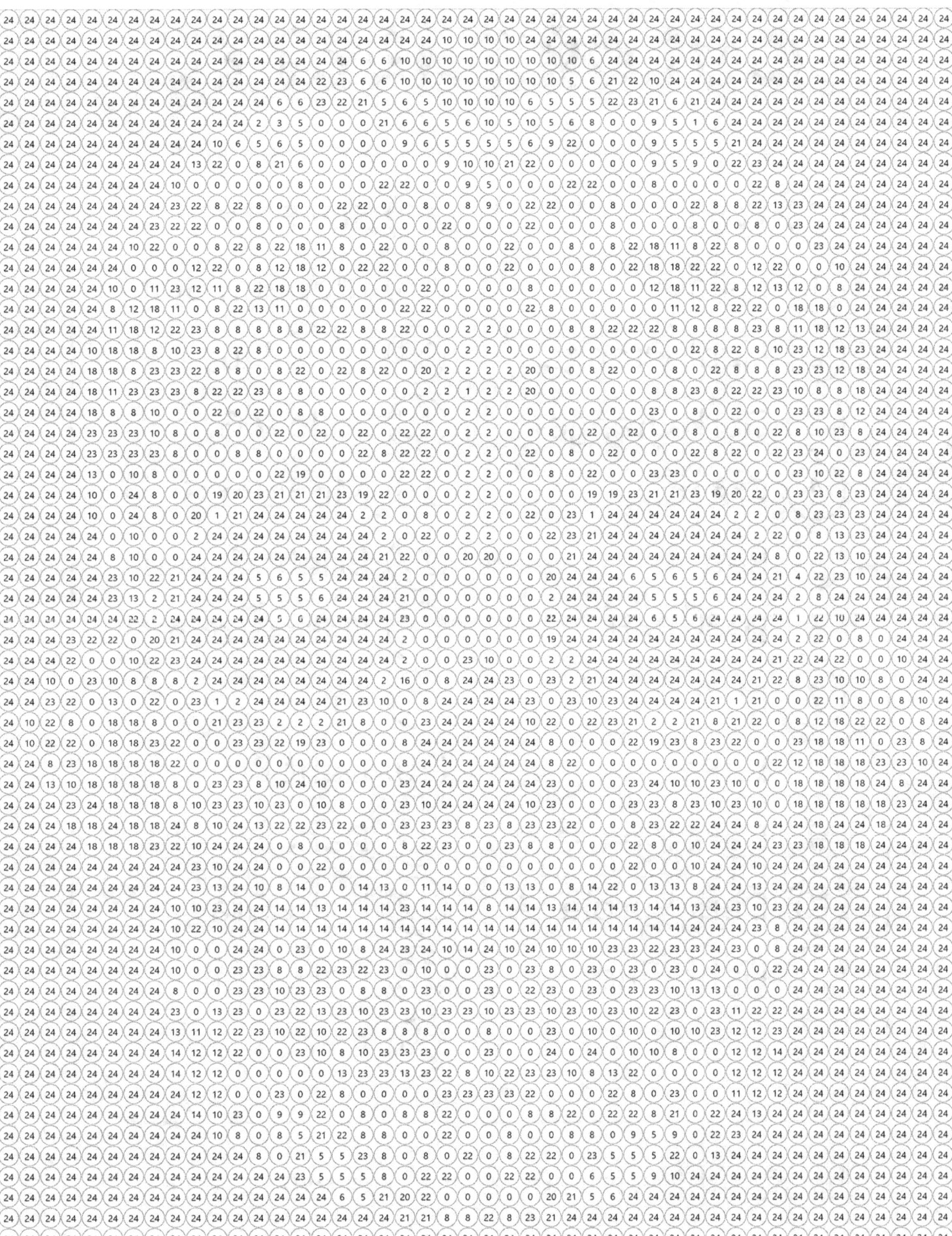

COLOR PALETTE

- ⓪ White
- ① Yellow
- ② Light Orange
- ③ Dark Orange
- ④ Cream
- ⑤ Red
- ⑥ Dark Red
- ⑦ Pink
- ⑧ Violet
- ⑨ Dark Pink
- ⑩ Dark Purple
- ⑪ Light Blue
- ⑫ Sky Blue
- ⑬ Medium Blue
- ⑭ Dark Blue
- ⑮ Yellow Green
- ⑯ Medium Green
- ⑰ Bright Green
- ⑱ Dark Green
- ⑲ Tan
- ⑳ Light Brown
- ㉑ Dark Brown
- ㉒ Light Gray
- ㉓ Dark Gray
- ㉔ Black

The world is my canvas and I create my reality.

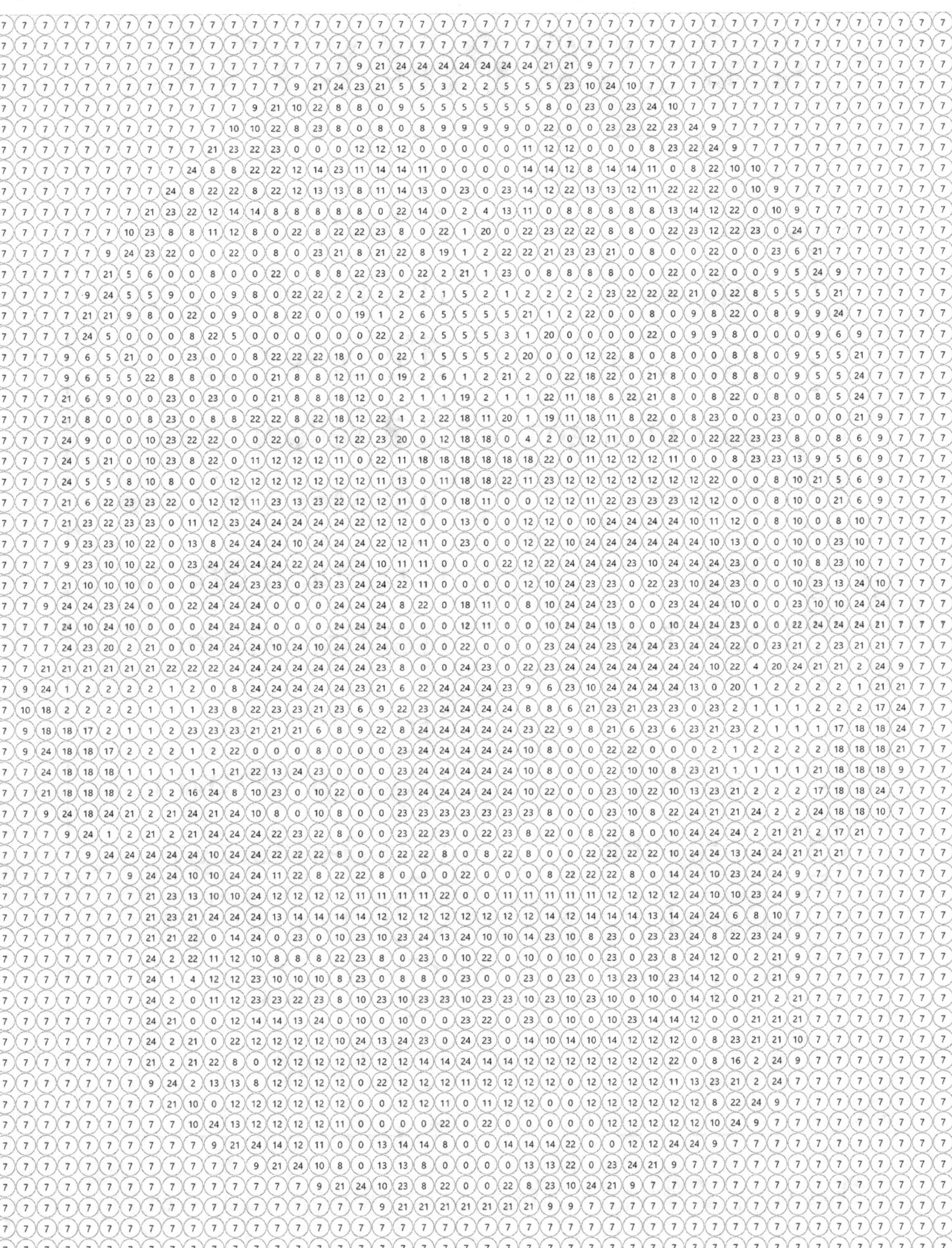

COLOR PALETTE

- ⓪ White
- ① Yellow
- ② Light Orange
- ③ Dark Orange
- ④ Cream
- ⑤ Red
- ⑥ Dark Red
- ⑦ Pink
- ⑧ Violet
- ⑨ Dark Pink
- ⑩ Dark Purple
- ⑪ Light Blue
- ⑫ Sky Blue
- ⑬ Medium Blue
- ⑭ Dark Blue
- ⑮ Yellow Green
- ⑯ Medium Green
- ⑰ Bright Green
- ⑱ Dark Green
- ⑲ Tan
- ⑳ Light Brown
- ㉑ Dark Brown
- ㉒ Light Gray
- ㉓ Dark Gray
- ㉔ Black

The world is my canvas and I create my reality.

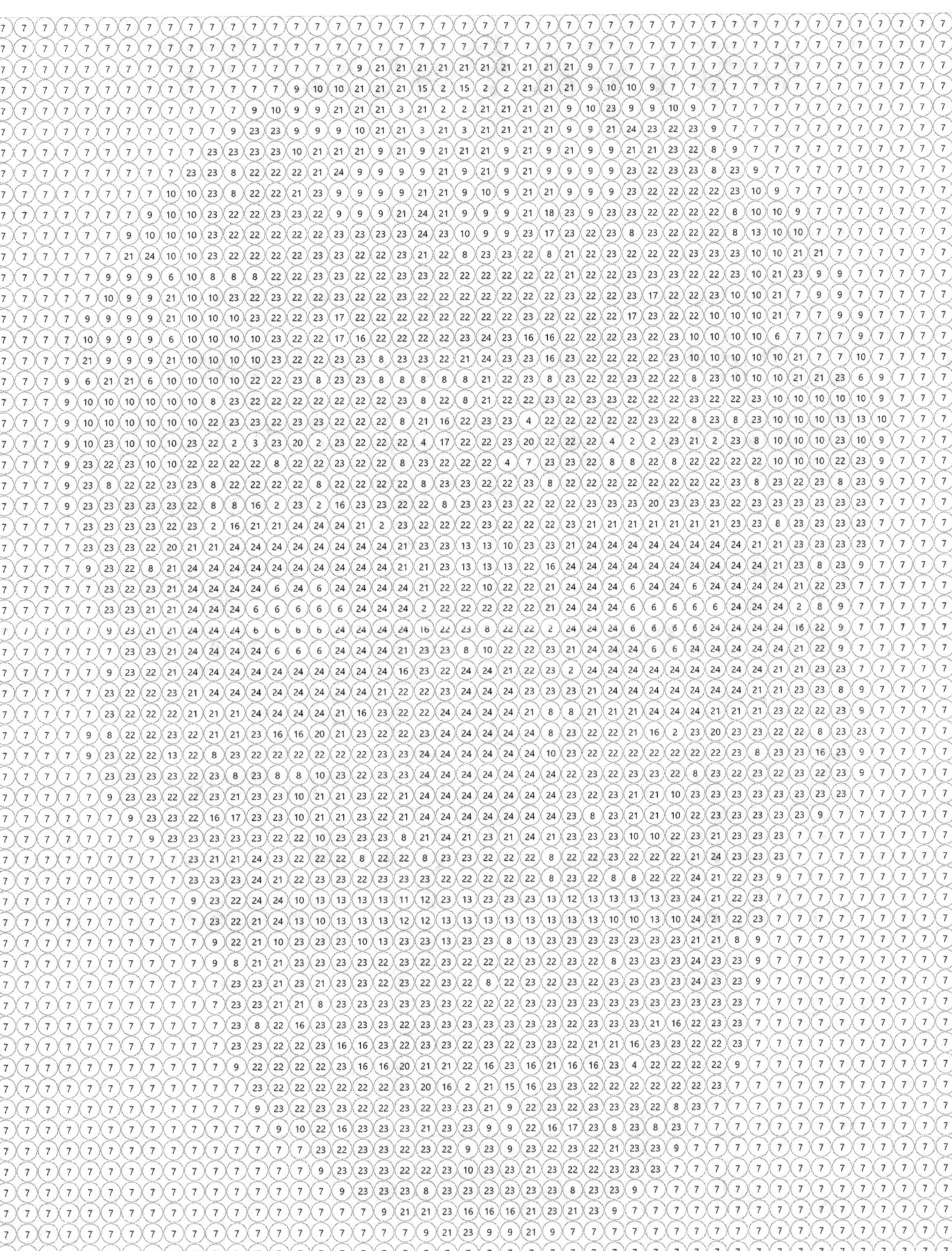

COLOR PALETTE

- ⓪ White
- ① Yellow
- ② Light Orange
- ③ Dark Orange
- ④ Cream
- ⑤ Red
- ⑥ Dark Red
- ⑦ Pink
- ⑧ Violet
- ⑨ Dark Pink
- ⑩ Dark Purple
- ⑪ Light Blue
- ⑫ Sky Blue
- ⑬ Medium Blue
- ⑭ Dark Blue
- ⑮ Yellow Green
- ⑯ Medium Green
- ⑰ Bright Green
- ⑱ Dark Green
- ⑲ Tan
- ⑳ Light Brown
- ㉑ Dark Brown
- ㉒ Light Gray
- ㉓ Dark Gray
- ㉔ Black

The world is my canvas and I create my reality.

COLOR PALETTE

- ⓪ White
- ① Yellow
- ② Light Orange
- ③ Dark Orange
- ④ Cream
- ⑤ Red
- ⑥ Dark Red
- ⑦ Pink
- ⑧ Violet
- ⑨ Dark Pink
- ⑩ Dark Purple
- ⑪ Light Blue
- ⑫ Sky Blue
- ⑬ Medium Blue
- ⑭ Dark Blue
- ⑮ Yellow Green
- ⑯ Medium Green
- ⑰ Bright Green
- ⑱ Dark Green
- ⑲ Tan
- ⑳ Light Brown
- ㉑ Dark Brown
- ㉒ Light Gray
- ㉓ Dark Gray
- ㉔ Black

The world is my canvas and I create my reality.

COLOR PALETTE

- ⓪ White
- ① Yellow
- ② Light Orange
- ③ Dark Orange
- ④ Cream
- ⑤ Red
- ⑥ Dark Red
- ⑦ Pink
- ⑧ Violet
- ⑨ Dark Pink
- ⑩ Dark Purple
- ⑪ Light Blue
- ⑫ Sky Blue
- ⑬ Medium Blue
- ⑭ Dark Blue
- ⑮ Yellow Green
- ⑯ Medium Green
- ⑰ Bright Green
- ⑱ Dark Green
- ⑲ Tan
- ⑳ Light Brown
- ㉑ Dark Brown
- ㉒ Light Gray
- ㉓ Dark Gray
- ㉔ Black

The world is my canvas and I create my reality.

COLOR PALETTE

- 0) White
- 1) Yellow
- 2) Light Orange
- 3) Dark Orange
- 4) Cream
- 5) Red
- 6) Dark Red
- 7) Pink
- 8) Violet
- 9) Dark Pink
- 10) Dark Purple
- 11) Light Blue
- 12) Sky Blue
- 13) Medium Blue
- 14) Dark Blue
- 15) Yellow Green
- 16) Medium Green
- 17) Bright Green
- 18) Dark Green
- 19) Tan
- 20) Light Brown
- 21) Dark Brown
- 22) Light Gray
- 23) Dark Gray
- 24) Black

The world is my canvas and I create my reality.

COLOR PALETTE

- ⓪ White
- ① Yellow
- ② Light Orange
- ③ Dark Orange
- ④ Cream
- ⑤ Red
- ⑥ Dark Red
- ⑦ Pink
- ⑧ Violet
- ⑨ Dark Pink
- ⑩ Dark Purple
- ⑪ Light Blue
- ⑫ Sky Blue
- ⑬ Medium Blue
- ⑭ Dark Blue
- ⑮ Yellow Green
- ⑯ Medium Green
- ⑰ Bright Green
- ⑱ Dark Green
- ⑲ Tan
- ⑳ Light Brown
- ㉑ Dark Brown
- ㉒ Light Gray
- ㉓ Dark Gray
- ㉔ Black

The world is my canvas and I create my reality.

COLOR PALETTE

- ⓪ White
- ① Yellow
- ② Light Orange
- ③ Dark Orange
- ④ Cream
- ⑤ Red
- ⑥ Dark Red
- ⑦ Pink
- ⑧ Violet
- ⑨ Dark Pink
- ⑩ Dark Purple
- ⑪ Light Blue
- ⑫ Sky Blue
- ⑬ Medium Blue
- ⑭ Dark Blue
- ⑮ Yellow Green
- ⑯ Medium Green
- ⑰ Bright Green
- ⑱ Dark Green
- ⑲ Tan
- ⑳ Light Brown
- ㉑ Dark Brown
- ㉒ Light Gray
- ㉓ Dark Gray
- ㉔ Black

The world is my canvas and I create my reality.

COLOR PALETTE

- ⓪ White
- ① Yellow
- ② Light Orange
- ③ Dark Orange
- ④ Cream
- ⑤ Red
- ⑥ Dark Red
- ⑦ Pink
- ⑧ Violet
- ⑨ Dark Pink
- ⑩ Dark Purple
- ⑪ Light Blue
- ⑫ Sky Blue
- ⑬ Medium Blue
- ⑭ Dark Blue
- ⑮ Yellow Green
- ⑯ Medium Green
- ⑰ Bright Green
- ⑱ Dark Green
- ⑲ Tan
- ⑳ Light Brown
- ㉑ Dark Brown
- ㉒ Light Gray
- ㉓ Dark Gray
- ㉔ Black

The world is my canvas and I create my reality.

COLOR PALETTE

- ⓪ White
- ① Yellow
- ② Light Orange
- ③ Dark Orange
- ④ Cream
- ⑤ Red
- ⑥ Dark Red
- ⑦ Pink
- ⑧ Violet
- ⑨ Dark Pink
- ⑩ Dark Purple
- ⑪ Light Blue
- ⑫ Sky Blue
- ⑬ Medium Blue
- ⑭ Dark Blue
- ⑮ Yellow Green
- ⑯ Medium Green
- ⑰ Bright Green
- ⑱ Dark Green
- ⑲ Tan
- ⑳ Light Brown
- ㉑ Dark Brown
- ㉒ Light Gray
- ㉓ Dark Gray
- ㉔ Black

The world is my canvas and I create my reality.

COLOR PALETTE

- ⓪ White
- ① Yellow
- ② Light Orange
- ③ Dark Orange
- ④ Cream
- ⑤ Red
- ⑥ Dark Red
- ⑦ Pink
- ⑧ Violet
- ⑨ Dark Pink
- ⑩ Dark Purple
- ⑪ Light Blue
- ⑫ Sky Blue
- ⑬ Medium Blue
- ⑭ Dark Blue
- ⑮ Yellow Green
- ⑯ Medium Green
- ⑰ Bright Green
- ⑱ Dark Green
- ⑲ Tan
- ⑳ Light Brown
- ㉑ Dark Brown
- ㉒ Light Gray
- ㉓ Dark Gray
- ㉔ Black

The world is my canvas and I create my reality.

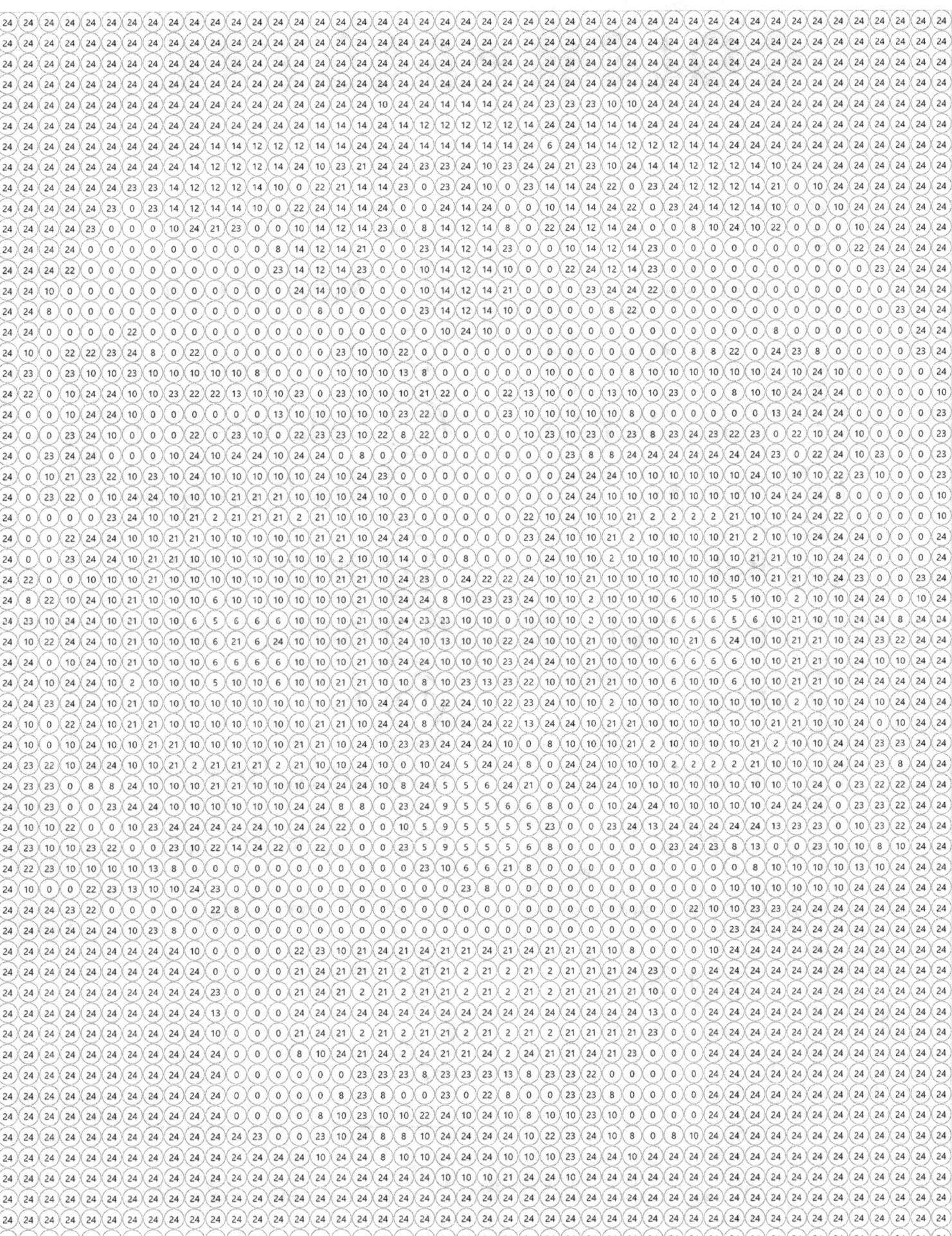

COLOR PALETTE

- ⓪ White
- ① Yellow
- ② Light Orange
- ③ Dark Orange
- ④ Cream
- ⑤ Red
- ⑥ Dark Red
- ⑦ Pink
- ⑧ Violet
- ⑨ Dark Pink
- ⑩ Dark Purple
- ⑪ Light Blue
- ⑫ Sky Blue
- ⑬ Medium Blue
- ⑭ Dark Blue
- ⑮ Yellow Green
- ⑯ Medium Green
- ⑰ Bright Green
- ⑱ Dark Green
- ⑲ Tan
- ⑳ Light Brown
- ㉑ Dark Brown
- ㉒ Light Gray
- ㉓ Dark Gray
- ㉔ Black

The world is my canvas and I create my reality.

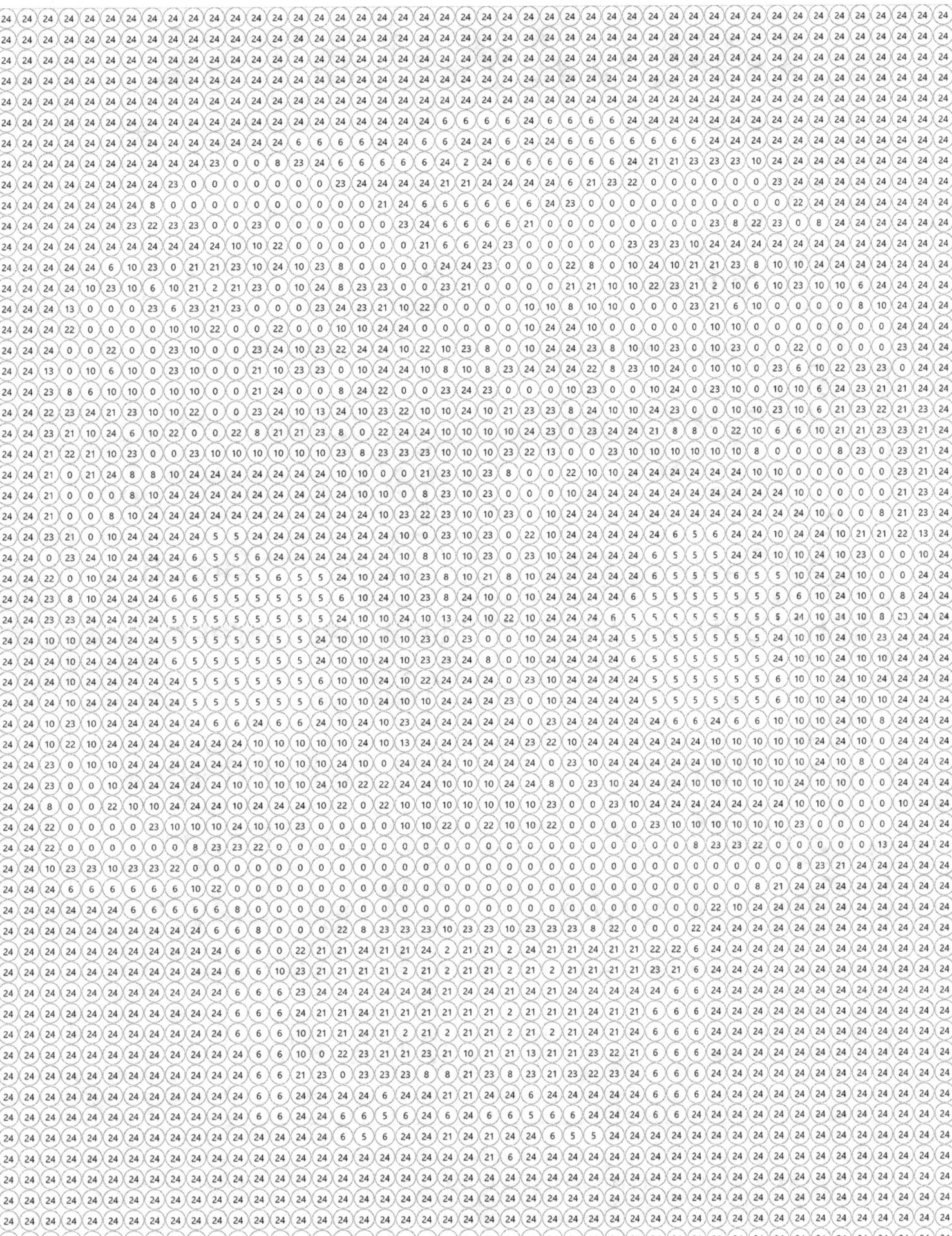

COLOR PALETTE

- ⓪ White
- ① Yellow
- ② Light Orange
- ③ Dark Orange
- ④ Cream
- ⑤ Red
- ⑥ Dark Red
- ⑦ Pink
- ⑧ Violet
- ⑨ Dark Pink
- ⑩ Dark Purple
- ⑪ Light Blue
- ⑫ Sky Blue
- ⑬ Medium Blue
- ⑭ Dark Blue
- ⑮ Yellow Green
- ⑯ Medium Green
- ⑰ Bright Green
- ⑱ Dark Green
- ⑲ Tan
- ⑳ Light Brown
- ㉑ Dark Brown
- ㉒ Light Gray
- ㉓ Dark Gray
- ㉔ Black

The world is my canvas and I create my reality.

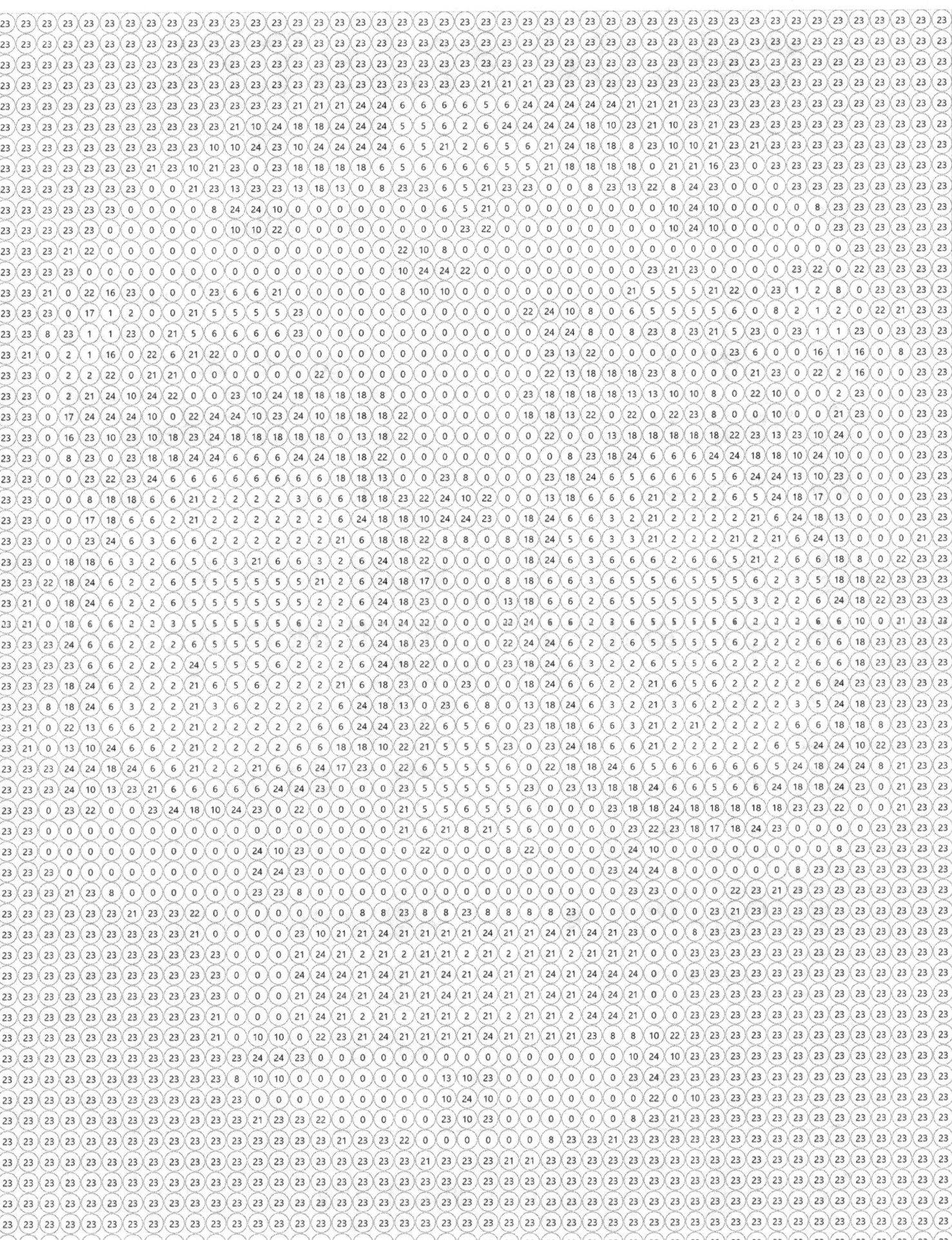

COLOR PALETTE

- ⓪ White
- ① Yellow
- ② Light Orange
- ③ Dark Orange
- ④ Cream
- ⑤ Red
- ⑥ Dark Red
- ⑦ Pink
- ⑧ Violet
- ⑨ Dark Pink
- ⑩ Dark Purple
- ⑪ Light Blue
- ⑫ Sky Blue
- ⑬ Medium Blue
- ⑭ Dark Blue
- ⑮ Yellow Green
- ⑯ Medium Green
- ⑰ Bright Green
- ⑱ Dark Green
- ⑲ Tan
- ⑳ Light Brown
- ㉑ Dark Brown
- ㉒ Light Gray
- ㉓ Dark Gray
- ㉔ Black

The world is my canvas and I create my reality.

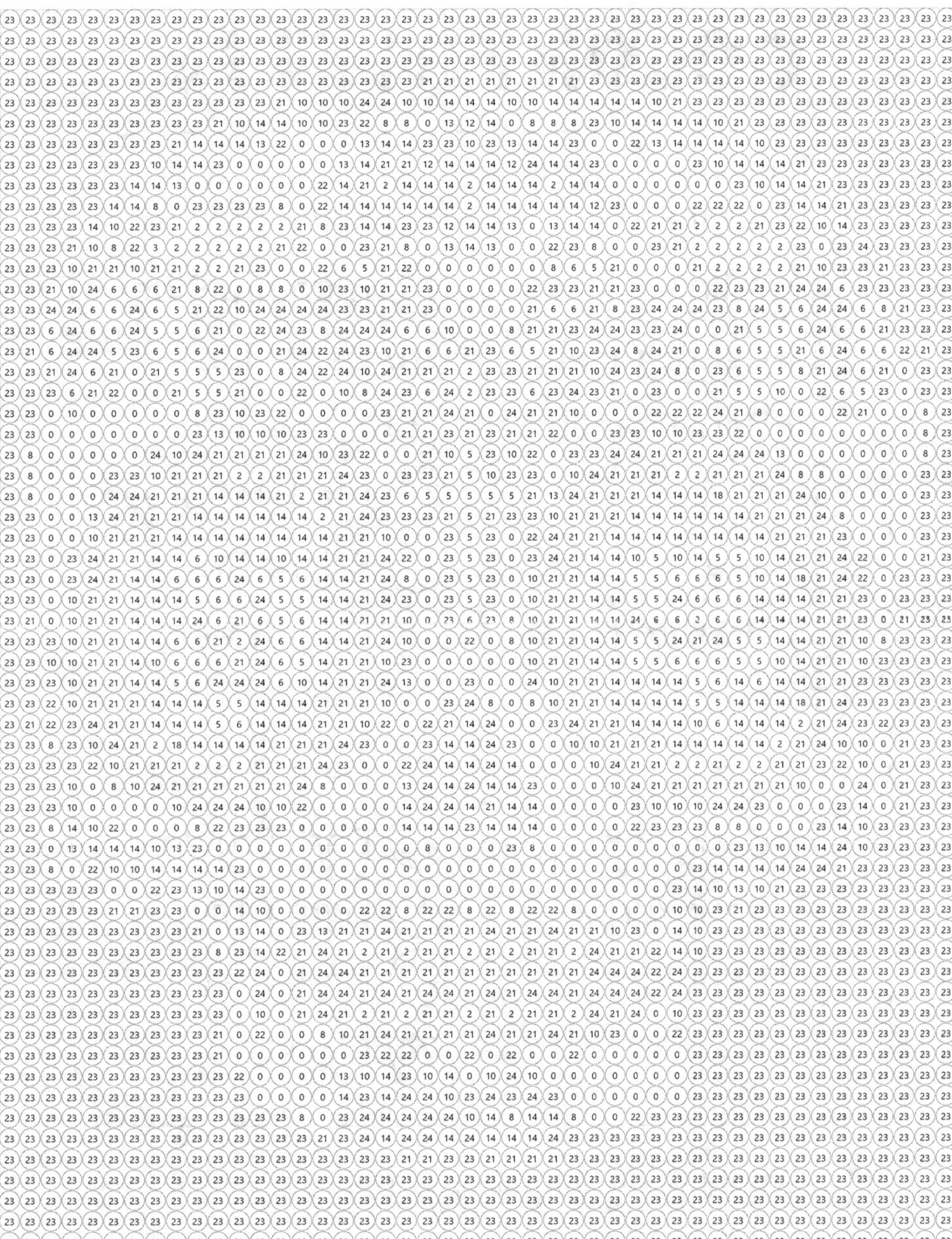

COLOR PALETTE

- ⓪ White
- ① Yellow
- ② Light Orange
- ③ Dark Orange
- ④ Cream
- ⑤ Red
- ⑥ Dark Red
- ⑦ Pink
- ⑧ Violet
- ⑨ Dark Pink
- ⑩ Dark Purple
- ⑪ Light Blue
- ⑫ Sky Blue
- ⑬ Medium Blue
- ⑭ Dark Blue
- ⑮ Yellow Green
- ⑯ Medium Green
- ⑰ Bright Green
- ⑱ Dark Green
- ⑲ Tan
- ⑳ Light Brown
- ㉑ Dark Brown
- ㉒ Light Gray
- ㉓ Dark Gray
- ㉔ Black

The world is my canvas and I create my reality.

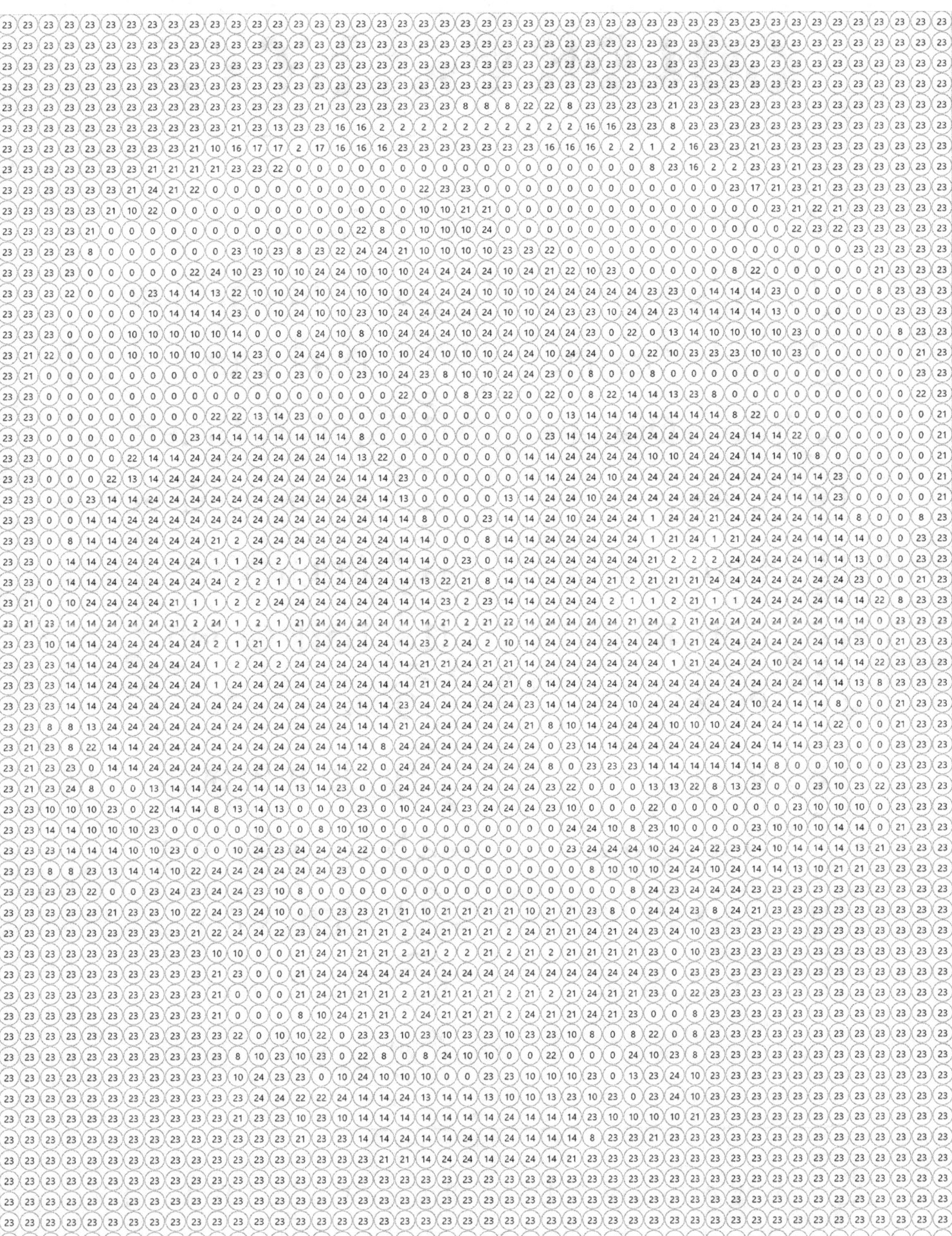

COLOR PALETTE

- ⓪ White
- ① Yellow
- ② Light Orange
- ③ Dark Orange
- ④ Cream
- ⑤ Red
- ⑥ Dark Red
- ⑦ Pink
- ⑧ Violet
- ⑨ Dark Pink
- ⑩ Dark Purple
- ⑪ Light Blue
- ⑫ Sky Blue
- ⑬ Medium Blue
- ⑭ Dark Blue
- ⑮ Yellow Green
- ⑯ Medium Green
- ⑰ Bright Green
- ⑱ Dark Green
- ⑲ Tan
- ⑳ Light Brown
- ㉑ Dark Brown
- ㉒ Light Gray
- ㉓ Dark Gray
- ㉔ Black

The world is my canvas and I create my reality.

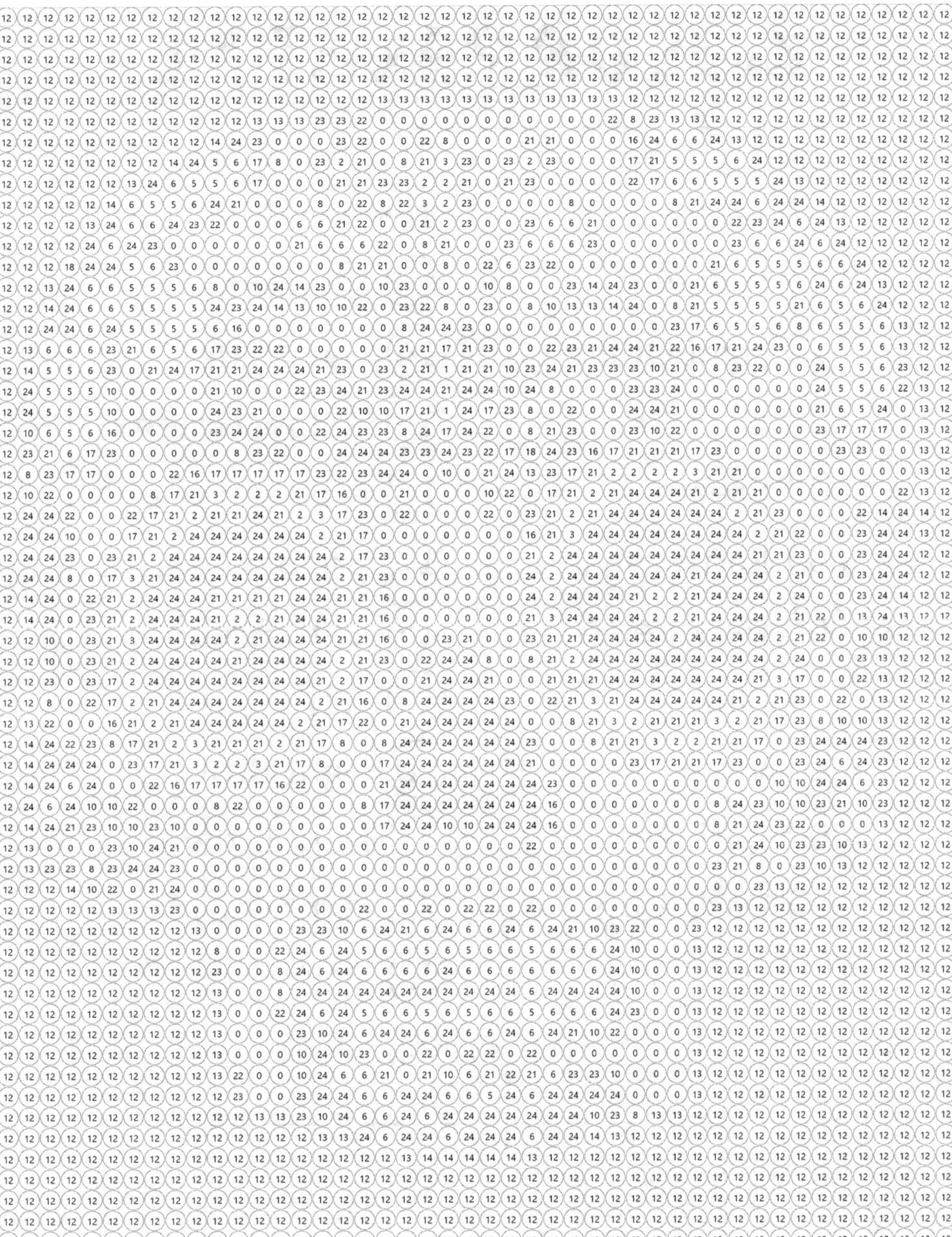

COLOR PALETTE

- ⓪ White
- ① Yellow
- ② Light Orange
- ③ Dark Orange
- ④ Cream
- ⑤ Red
- ⑥ Dark Red
- ⑦ Pink
- ⑧ Violet
- ⑨ Dark Pink
- ⑩ Dark Purple
- ⑪ Light Blue
- ⑫ Sky Blue
- ⑬ Medium Blue
- ⑭ Dark Blue
- ⑮ Yellow Green
- ⑯ Medium Green
- ⑰ Bright Green
- ⑱ Dark Green
- ⑲ Tan
- ⑳ Light Brown
- ㉑ Dark Brown
- ㉒ Light Gray
- ㉓ Dark Gray
- ㉔ Black

The world is my canvas and I create my reality.

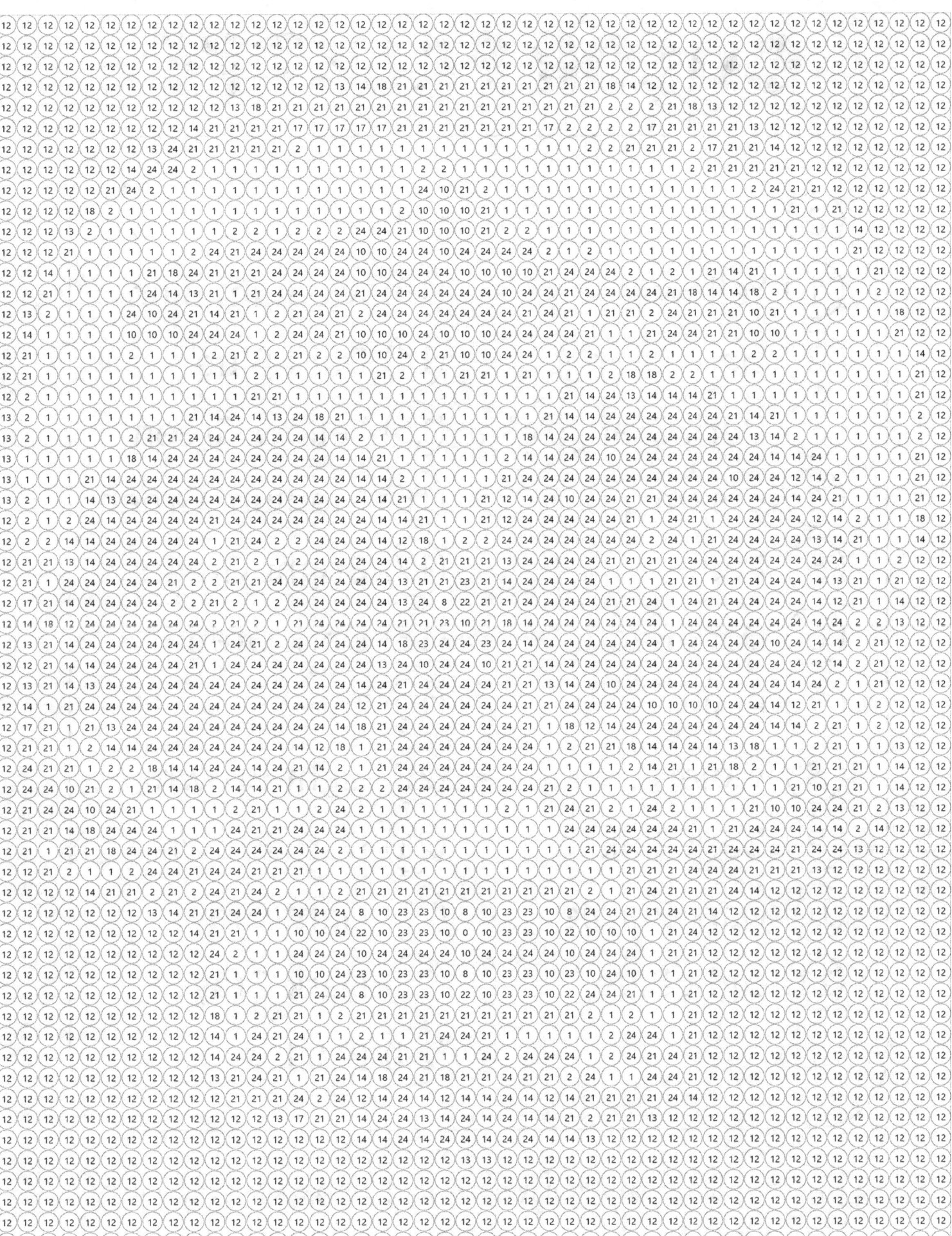

COLOR PALETTE

- ⓪ White
- ① Yellow
- ② Light Orange
- ③ Dark Orange
- ④ Cream
- ⑤ Red
- ⑥ Dark Red
- ⑦ Pink
- ⑧ Violet
- ⑨ Dark Pink
- ⑩ Dark Purple
- ⑪ Light Blue
- ⑫ Sky Blue
- ⑬ Medium Blue
- ⑭ Dark Blue
- ⑮ Yellow Green
- ⑯ Medium Green
- ⑰ Bright Green
- ⑱ Dark Green
- ⑲ Tan
- ⑳ Light Brown
- ㉑ Dark Brown
- ㉒ Light Gray
- ㉓ Dark Gray
- ㉔ Black

The world is my canvas and I create my reality.

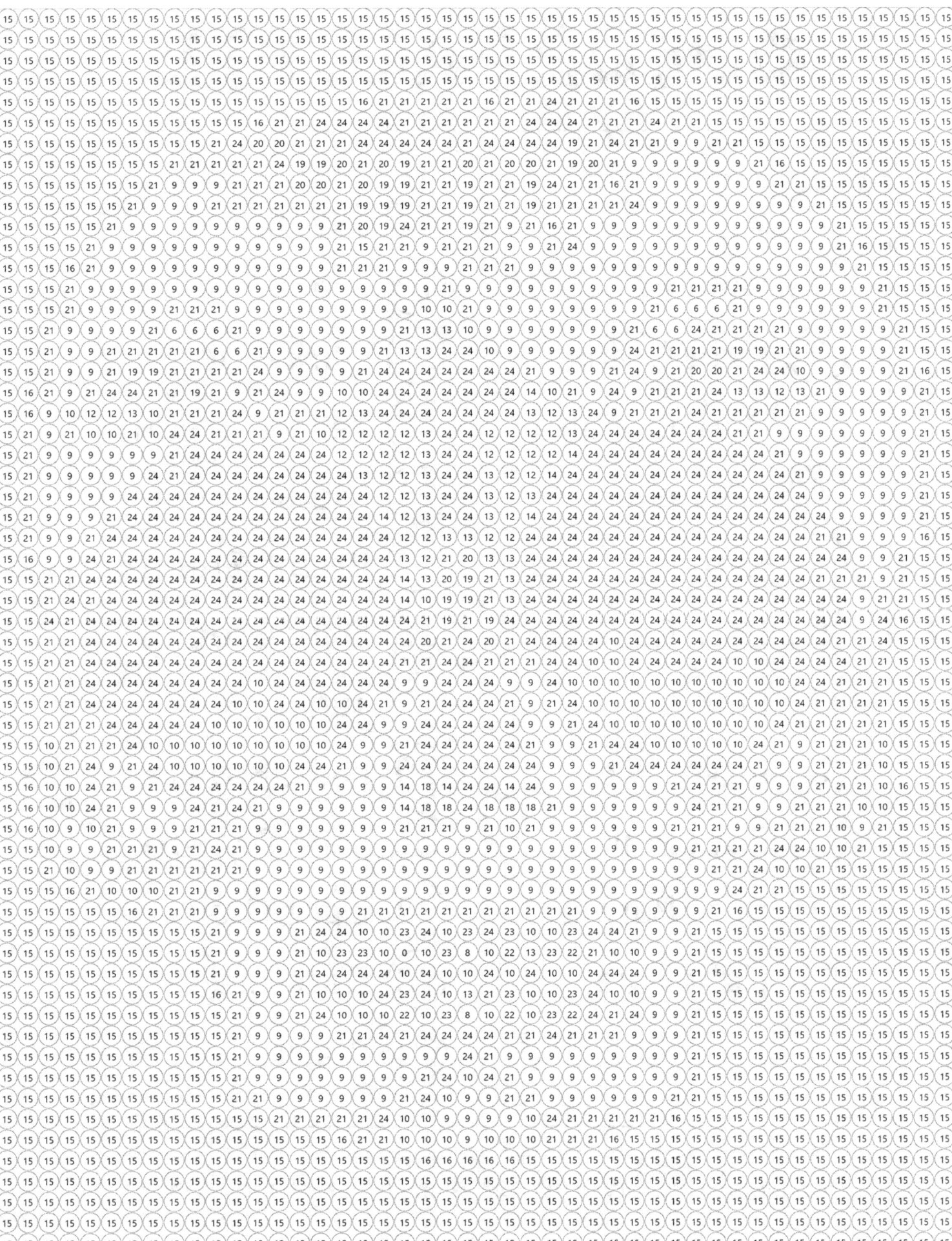

COLOR PALETTE

- ⓪ White
- ① Yellow
- ② Light Orange
- ③ Dark Orange
- ④ Cream
- ⑤ Red
- ⑥ Dark Red
- ⑦ Pink
- ⑧ Violet
- ⑨ Dark Pink
- ⑩ Dark Purple
- ⑪ Light Blue
- ⑫ Sky Blue
- ⑬ Medium Blue
- ⑭ Dark Blue
- ⑮ Yellow Green
- ⑯ Medium Green
- ⑰ Bright Green
- ⑱ Dark Green
- ⑲ Tan
- ⑳ Light Brown
- ㉑ Dark Brown
- ㉒ Light Gray
- ㉓ Dark Gray
- ㉔ Black

The world is my canvas and I create my reality.

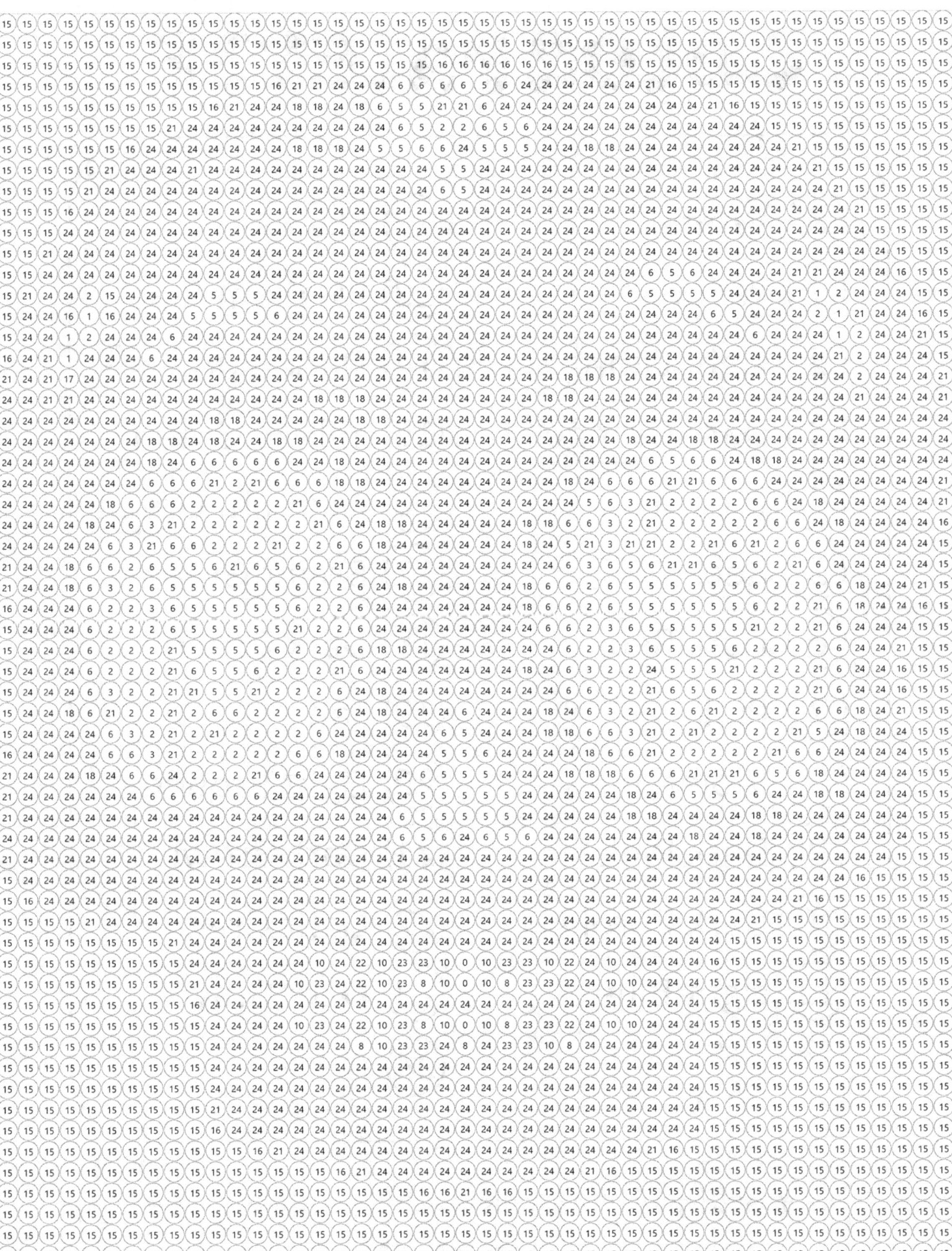

COLOR PALETTE

⓪ White
① Yellow
② Light Orange
③ Dark Orange
④ Cream
⑤ Red
⑥ Dark Red
⑦ Pink
⑧ Violet
⑨ Dark Pink
⑩ Dark Purple
⑪ Light Blue

⑫ Sky Blue
⑬ Medium Blue
⑭ Dark Blue
⑮ Yellow Green
⑯ Medium Green
⑰ Bright Green
⑱ Dark Green
⑲ Tan
⑳ Light Brown
㉑ Dark Brown
㉒ Light Gray
㉓ Dark Gray
㉔ Black

The world is my canvas and I create my reality.

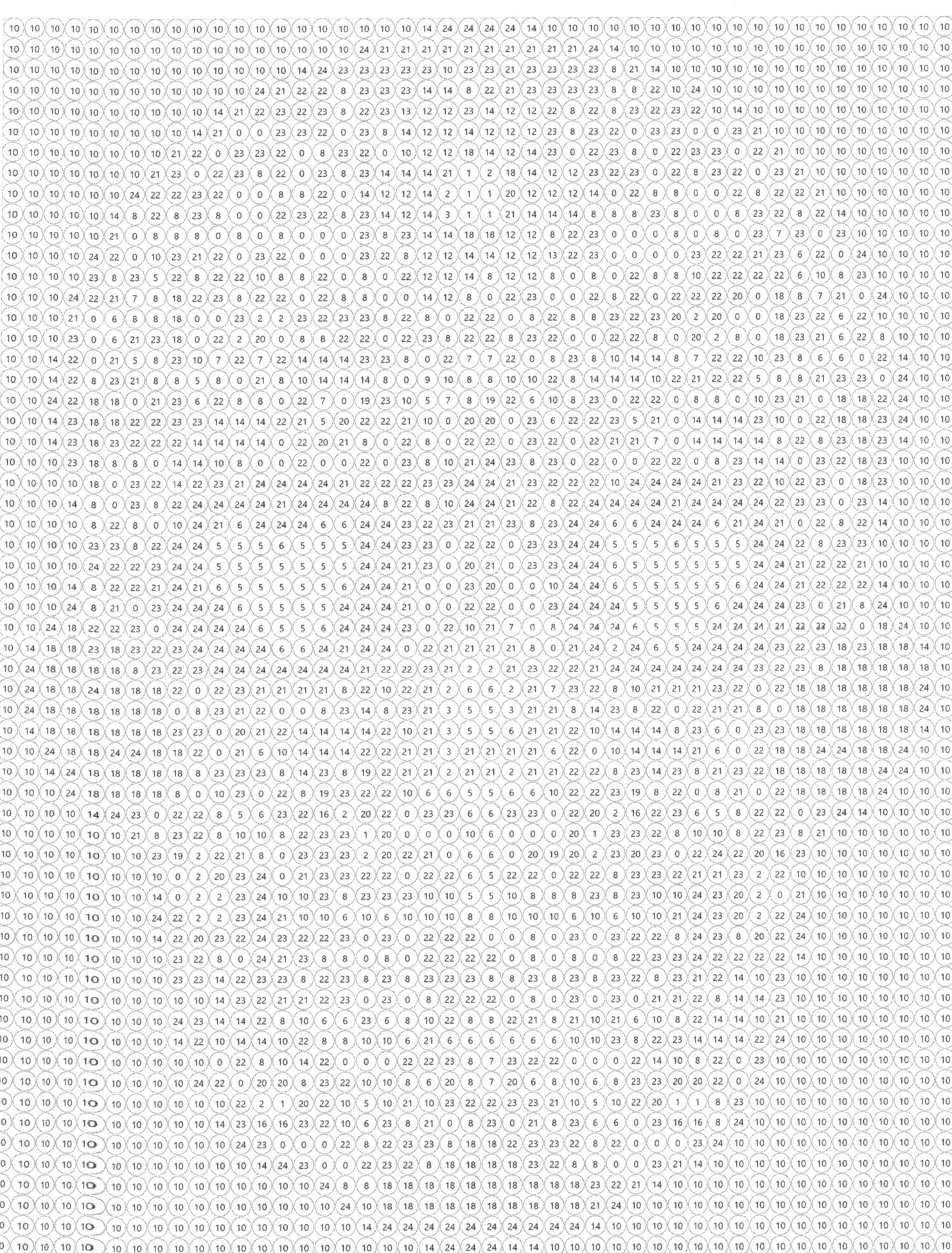

www.ingramcontent.com/pod-product-compliance
Lightning Source LLC
Chambersburg PA
CBHW080906220526
45466CB00011BA/3483

9781687863263